THE RABBIT AND THE EVIL WOLF

Owl Saves The Day

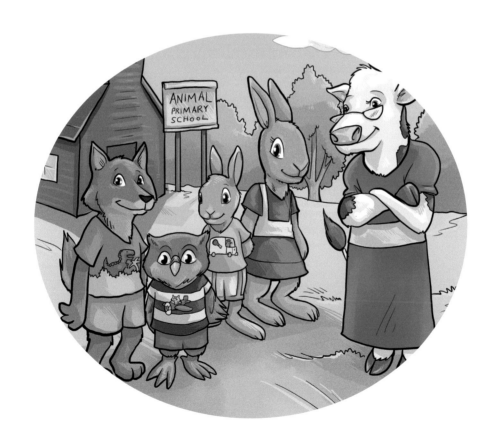

HARVINDER DOAL

AuthorHouse™ UK
1663 Liberty Drive
Bloomington, IN 47403 USA
www.authorhouse.co.uk
Phone: 0800 047 8203 (Domestic TFN)
+44 1908 723714 (International)

Published by AuthorHouse 08/02/2019

ISBN: 978-1-7283-8161-9 (sc)
ISBN: 978-1-7283-8160-2 (e)

authorHOUSE®

THE RABBIT
AND THE EVIL WOLF

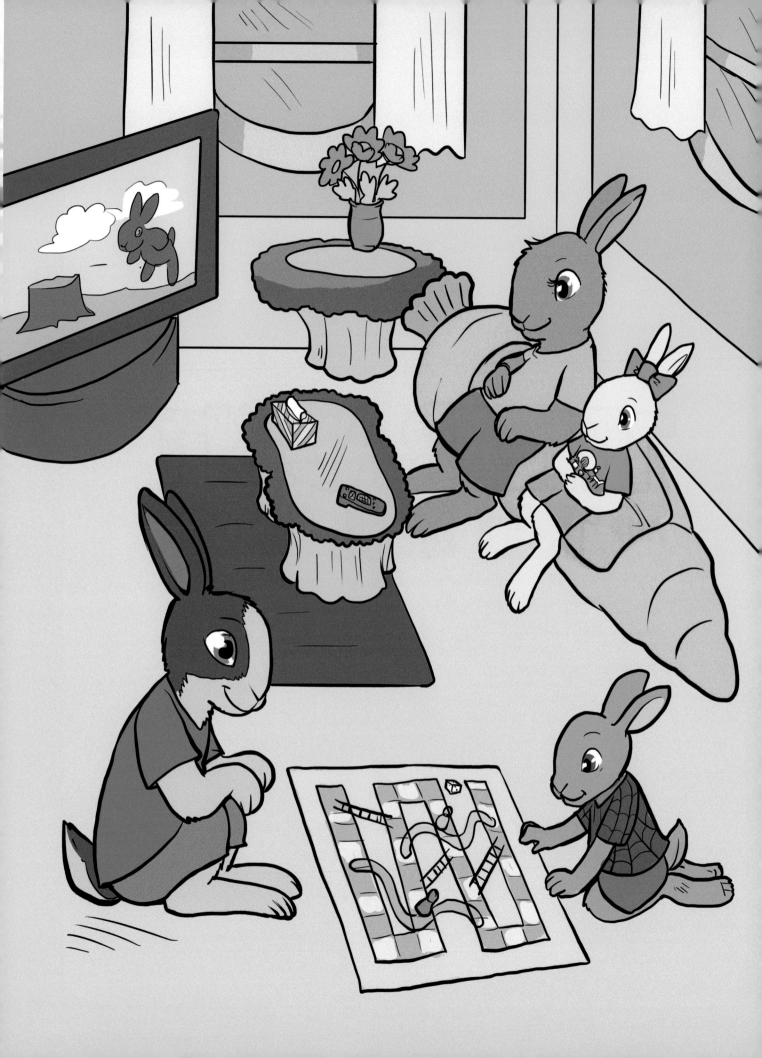

Once there lived a Rabbit with his Mummy, Daddy and his younger sister, who were very kind to each other. When he is at home, he listens to his Mummy all the time. If Mummy tells him to help her clean his room, he will just do it and not answer her back in anyway.

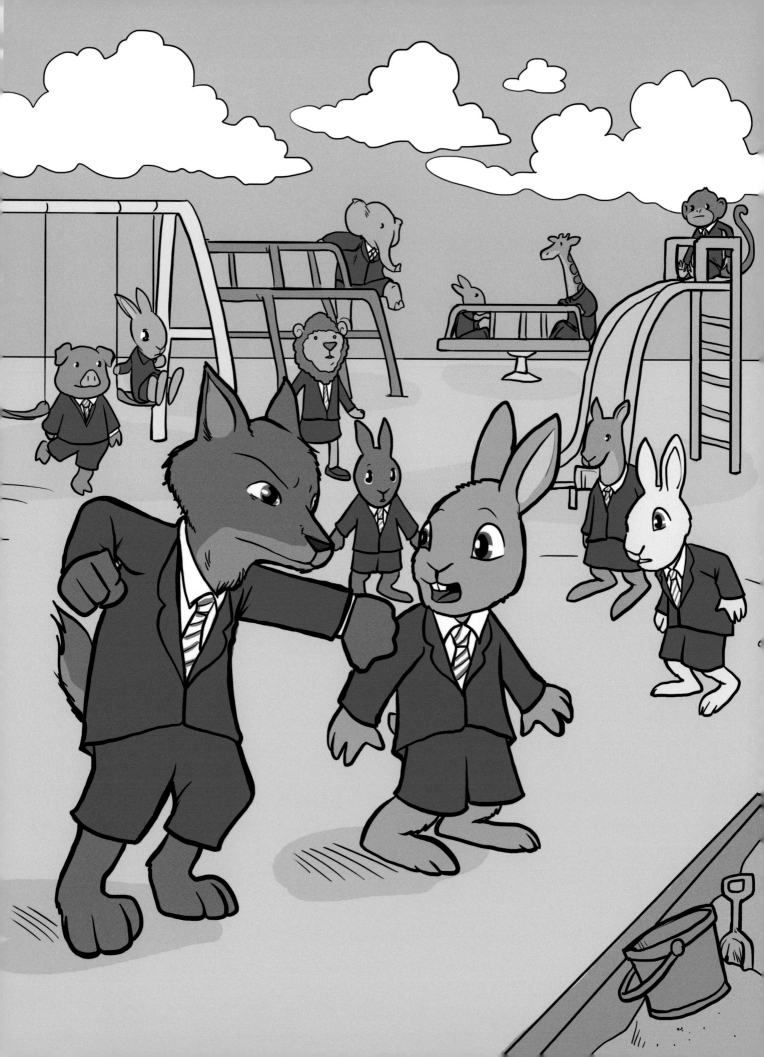

One day during school playtime the Rabbit was playing with his friends and suddenly, the Evil Wolf came up to him and started to hit poor Rabbit for no reason.

The Rabbit shouted "Help! Someone help me!" The friends wanted to help him but they got scared. The Rabbit was feeling very upset while he was being hit and there was no one helping him.

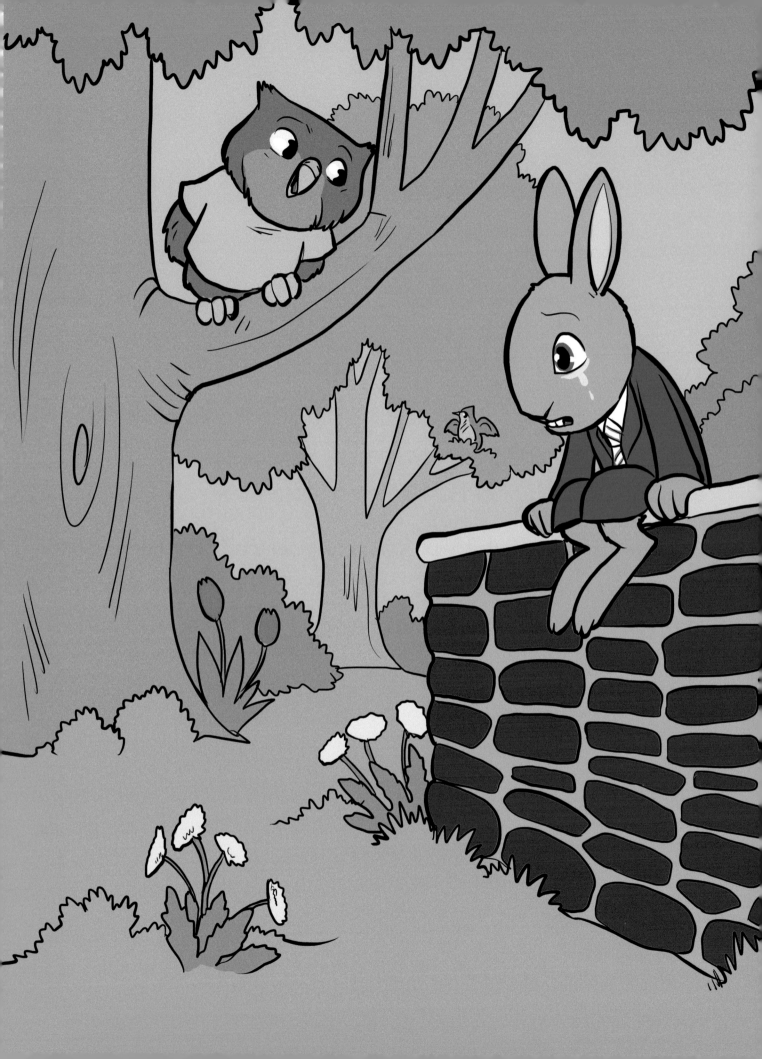

Soon after there was an Owl flying by and saw the Rabbit crying. She asked "What happened Rabbit? Why are you crying?". The Rabbit said, "The Evil Wolf has hit me!" The Owl thought of a plan and told the Rabbit, "You should tell your teacher, are you planning to tell her", "No! I am too scared to see my teacher" the Rabbit replied. The Owl said, "You need to go and see your teacher and tell her what happened".

Rabbit did not want to go to his teacher as he was scared that she might not listen to him. He was also very worried that the Evil Wolf may get angry and hit him again. Rabbit said to the Owl "No, I am fine". The Owl asked him "Why do you not want to go to the teacher?" The Rabbit said "I just do not want to." The Owl and Rabbit agreed that the best thing to do for now was to go home, think about it and come back the next day.

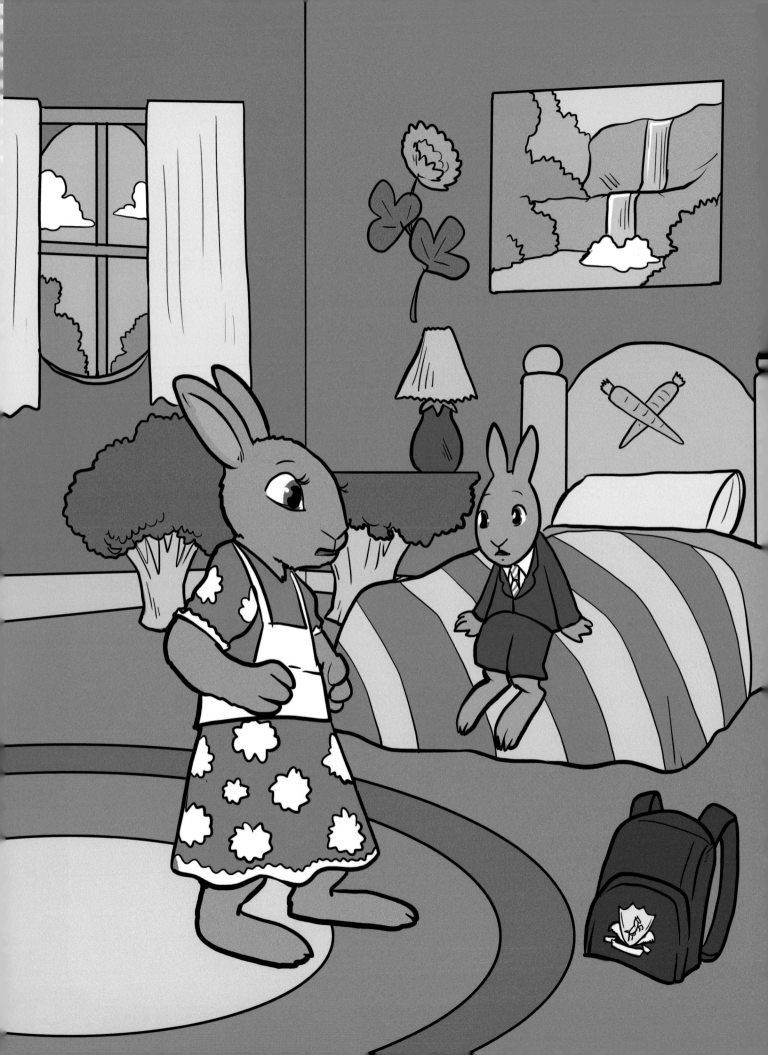

When Rabbit got home, he was very quiet and his Mummy noticed that he is not talking a lot today. Normally, he would be chatty when he came back from school.

Mummy went to Rabbit's room and asked him "What is wrong with you today? Why are you so quiet? Did anything happen at school today?"

The Rabbit said "Nothing has happened in school today."

"I am your Mummy so you don't need to worry about sharing anything with me", said Mummy

Rabbit thought for a moment and then decided to tell her.

Rabbit started to cry and told Mummy rabbit "That Evil Wolf had hit him at school today"

"Did you tell your teacher?" asked Mummy.

"No, I didn't tell my teacher" replied Rabbit.

"Why didn't you tell your teacher?" said Mummy.

"I was scared to tell my teacher" replied Rabbit.

Mummy suggested you must go and see your teacher as she will be able to help you. Sometimes the teacher doesn't know what is going on, if you don't tell them, I think you should go and see her tomorrow and tell her everything that has happened today.

Rabbit agreed to go and see his teacher tomorrow.

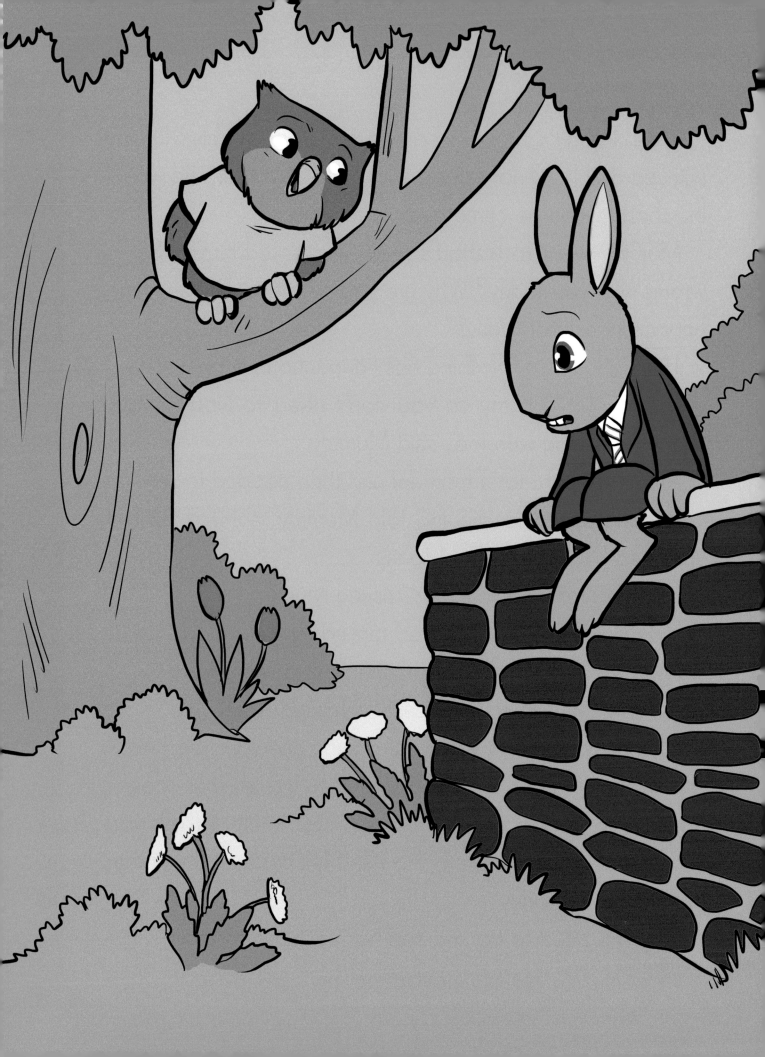

So the next day before going to school Rabbit met with the Owl and the and talked about the incident that had happened.

The Rabbit told the Owl "I will talk to my teacher when I get to school". Rabbit got to school there was his teacher taking the class register.

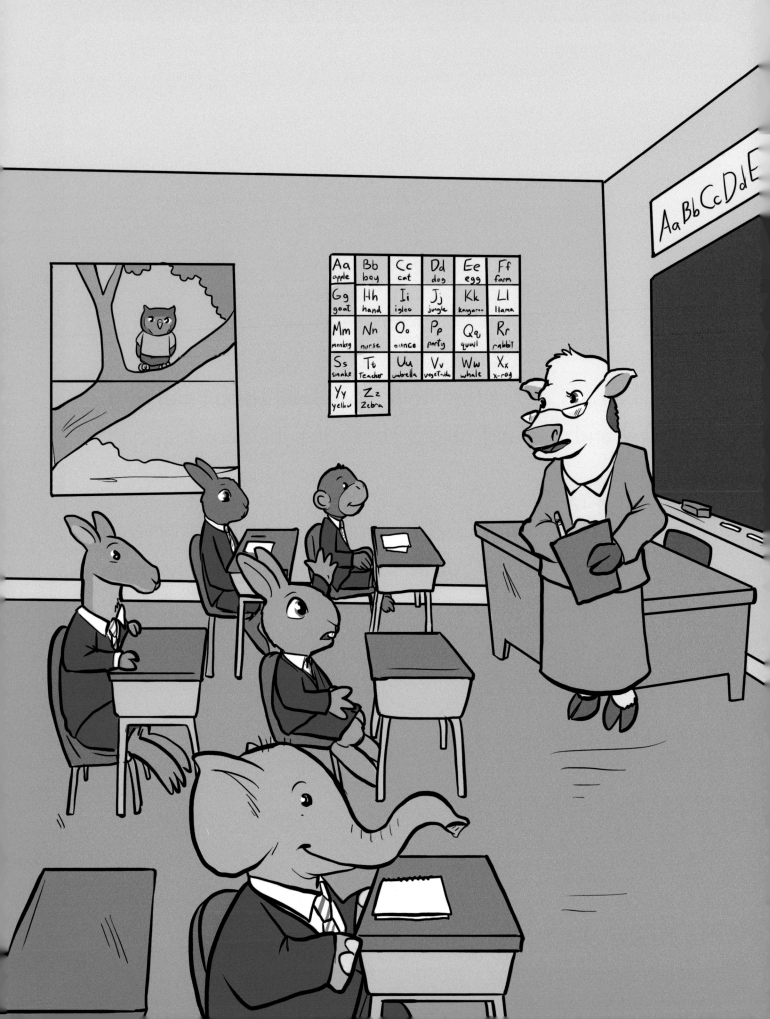

After the teacher had taken the register, Rabbit raised his hand slowly and steadily to speak to her. He said "yesterday the Evil Wolf came up to me and hit me no reason

The teacher said "Why didn't you come to me yesterday, when it happened."

Rabbit said, "I was feeling scared to talk to you about it."

The teacher comforted the Rabbit and said "I am always here to help you if you have any problems or worries, therefore, do not be afraid to come to me. Well done for being courageous in coming and telling me."

Now that you have told me, I will speak to the Evil Wolf and give him the right punishment required.

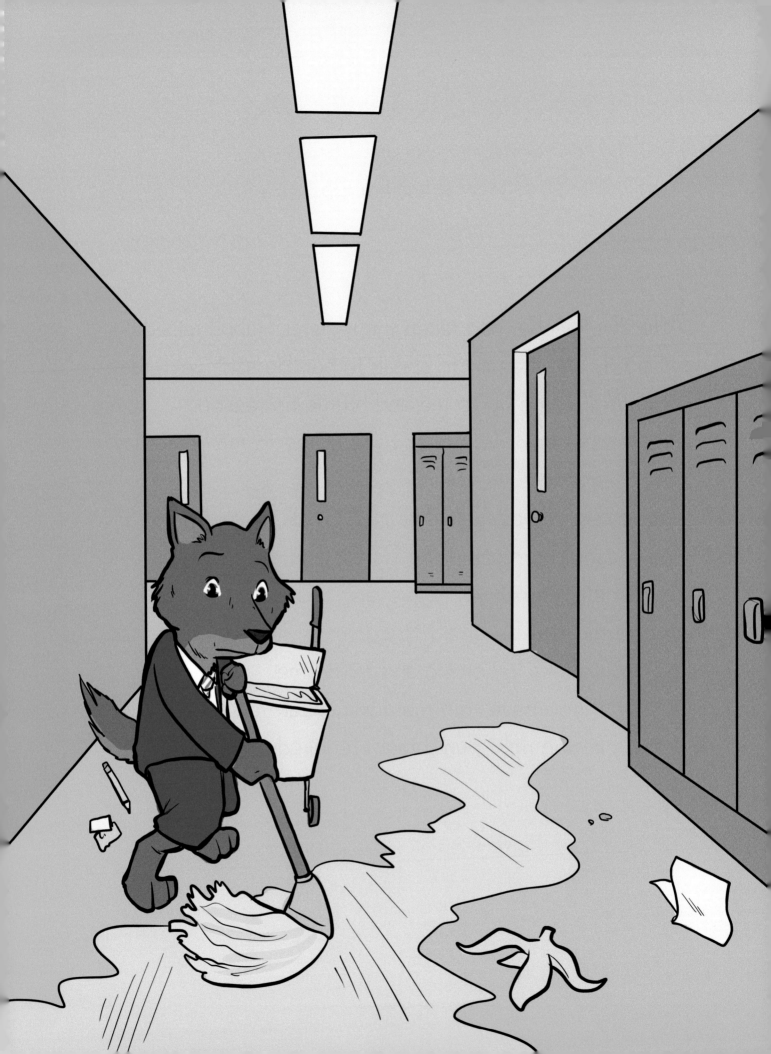

The Rabbit and the Evil Wolf explained to the teacher what had happened yesterday. After listening to both of them the teacher decided that the Evil Wolf had not been very nice and kind to the Rabbit, so he was not allowed to have a lunch break for a whole week. Instead he had to stay in the classroom to tidy up and make sure the locker room was kept spotless.

The Evil Wolf had realised how upset he made the Rabbit, so went looking for him. When he met the Rabbit, he apologised by saying 'I am really sorry for what I have done.'' The kind Rabbit forgave the Evil Wolf but made him promise not to hit or upset anyone else from this day forward. On agreeing to this, the Rabbit and Evil Wolf became best friends.

ABOUT THE AUTHOR

My reason for publishing this book is to give children the awareness of bullying and its solution if they are a victim of it. I have personally gone through the experience of being a bullying victim and know how it feels to be one and want to prevent others from going through these potential circumstances. To also explain to children that it is very important to go the their teacher if there is any problems with them and they will deal with it.

Consequences of Neglecting Dyslexia

Dyslexia Matters

HARVINDER DOAL

Printed in the United States
By Bookmasters